To Carol and Mike

A special remembrance
for your 55th Wedding
Anniversary !

With love
Dorothy and Bob Lauer

PROVENCE

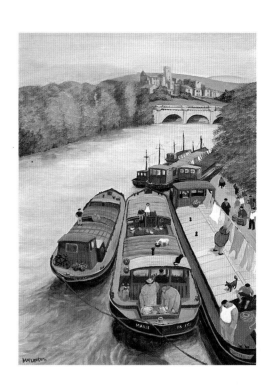

First published in Great Britain in 1993
by Sinclair-Stevenson, an imprint of Reed Consumer Books Ltd.

Macmillan Publishing Company
866 Third Avenue
New York, NY 10022

Printed in Great Britain

Macmillan Publishing Company is part of the Maxwell
Communication Group of Companies.

Library of Congress Cataloging-in-Publication Data

Mayle, Peter.
 Provence/text by Peter Mayle: paintings by Margaret Loxton.
 p. cm.
 Includes index.
 ISBN 0-684-19664-6
 1. Provence (France) —Social life and customs—Pictorial works.
 2. Provence (France) in art. I. Loxton, Margaret. II. Title
 DC611.P9545M39 1993 93-5084 CIP
 944'.9 dc20

Typeset in Palatino by Rowland Phototypesetting Limited,
Bury St Edmunds, Suffolk

Macmillan books are available at special discounts for bulk purchases
for sales promotions, premiums, fund-raising, or educational use.
For details, contact:
 Special Sales Director
 Macmillan Publishing Company
 866 Third Avenue
 New York, NY 10022

10 9 8 7 6 5 4 3 2 1

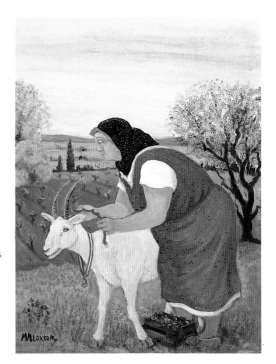

PROVENCE

Text by Peter Mayle
Paintings by Margaret Loxton

Macmillan Publishing Company
New York

Maxwell Macmillan International
New York Oxford Singapore Sydney

Each spring, as the rows of vines, bony and bare and black, begin to soften with a green blur of new leaves, the landscape can be seen to sprout with an altogether different crop – still, quiet figures, perched on crags or balanced on those ingenious folding stools that provide minimal support and maximum discomfort. They have easels, and quivers filled with brushes and crayons. They wear hats, and frowns of concentration. They seem to be hypnotized by distance until, with sudden pecks of the brush, they set to work committing Provence to canvas.

I have always been fascinated by artists, not only because of their skill – effortless, it appears, although I'm sure it's not – but also because of what they choose to see, the way they edit their subjects to conform to their own private view of the world. And so I can never resist sidling up behind them, taking great care not to disturb the muse, and having a quick look over the artistic shoulder. It's visual eavesdropping, I know, and a shameful invasion of creative privacy, but I can't help it. I want to see what they're up to, if their idea of Provence is anything like mine.

Almost always, what I see is uninhabited scenery, and it's easy to understand why. There's the light, of course, and the great blue sweep of the sky. There are mountains that change from green to mauve, and clouds shaped like cigars that develop a gauzy pink

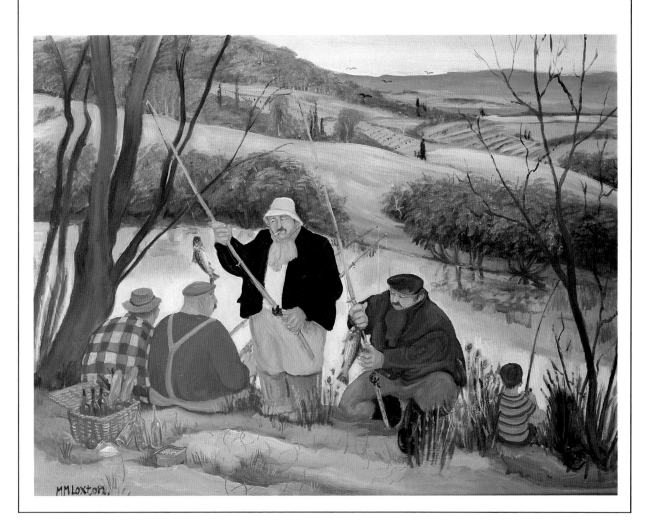

La Bavarde

tinge at sunset. There are villages the colour of pale honey, placed so perfectly on the hillsides that you feel they have been put there with no other purpose than to please the onlooker. There are olive groves that ripple silver-green in the wind, oceans of cherry blossom, chapels and abbeys and *châteaux* and fountains, Roman ruins and troglodytes' caves. You would have to be afflicted with a tin eye not to be captivated by it all.

But very seldom, as I peer over the artistic shoulder, do I see an aspect of Provence that – for me, at least – is as picturesque as any vista, and often as solid and monumental as any ancient building: the human scenery.

That is why I take such enormous pleasure in Margaret Loxton's work. Her people are not afterthoughts, or token figures put in for the sake of perspective. Her paintings are not merely inhabited; they teem with life – men and women, dogs and chickens, cats and geese, the occasional goat – all captured in a style that is at the same time comic, affectionate and true.

I have never met any of the people she paints, but I know them. I know the burly man in his *bleu de travail* overalls with his nose twitching over a glass of red wine. He'll finish that in silence, call for another one and then look around the bar for a sympathetic ear he can complain to about the injustice of life, the scandalously low price his melons fetched in Cavaillon, his long-suffering liver or *les imbéciles* in Brussels. And, once he's settled the state of

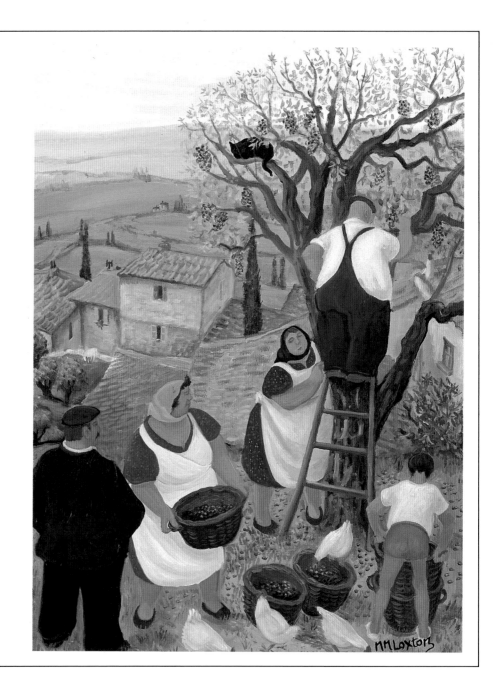

Olive Harvest in the Lubéron

the world to his satisfaction, he'll hoist himself on his tractor and go back to nursing his vines.

I know the group of neighbours cropping lavender, pausing every now and then to ease their backs and continue conversations that began over breakfast. These won't be intimate exchanges, as the listener is likely to be half a field away from the speaker. But the Provençal lung, trained and strengthened by years of competition with the Mistral, is a hardy organ with an impressive range, undaunted by minor geographical obstacles.

I know the family sitting down to Sunday lunch at a long table out of doors. There are three generations of them. The children are drinking *Orangina* and hoping there will be *pommes frites*. Their grandfather shares a bench with them, within easy swatting distance if they should become too noisy. The others raise their glasses and toast another sunny day. Three hours, maybe more, will pass before they feel they have done justice to the most important business of the weekend.

I know the men playing *boules* in the village, grunting with disbelief at the undeserved good luck of their opponents. The spectators, experts to a man, shake their heads at the standard of play. *Dieu*, look at that! How could anyone miss a chance like that? They're playing like foreigners. Any moment now, a particularly stinging criticism will be overheard, and the match will be halted to allow time for a brisk

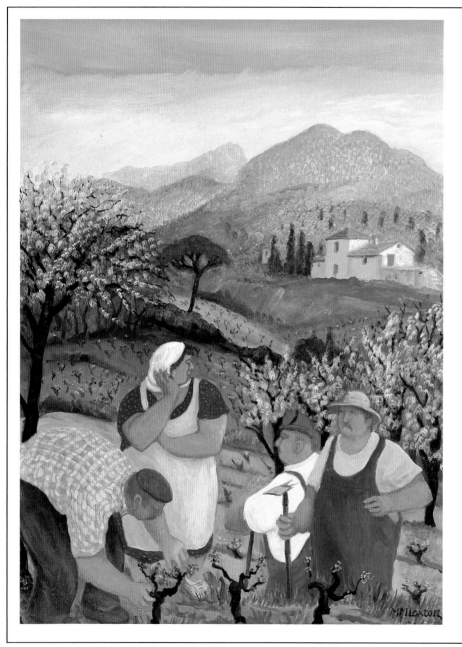

Tending the Vines,
Les Alpilles

and enjoyable exchange of insults.

You will notice that these characters, and all the others you meet in the pages of this book, share a certain sturdiness. Their necks and arms would do credit to well-established trees, and you feel that a convivial clap on the back from one of those meaty hands would knock the breath from your body. This abundance of solid flesh and bone may simply reflect a lifetime of hard work with the knife and fork, but I think it also reveals an interesting bias on the part of the artist. Margaret Loxton ignores skinny people, and quite right too. They would look out of place, uncomfortable and flimsy among men and women whose girth is measured in metres.

But do they really exist, these human monuments, or are they just figments (if you can describe anyone who weighs as much as a *Deux Chevaux* a figment) of the Loxton imagination? Here is an unsolicited testimonial from a totally reliable source.

One of our neighbours stopped at the house for the drink that would give him the necessary steam to travel the final five hundred metres to his own home. The colour proofs of the paintings had arrived that afternoon, and were scattered on the table. I thought they might interest him, that he would recognise villages like Bonnieux and Goult, and so I asked him to look through them.

He took his time, nodding here and there as he came across a familiar scene. He admired the

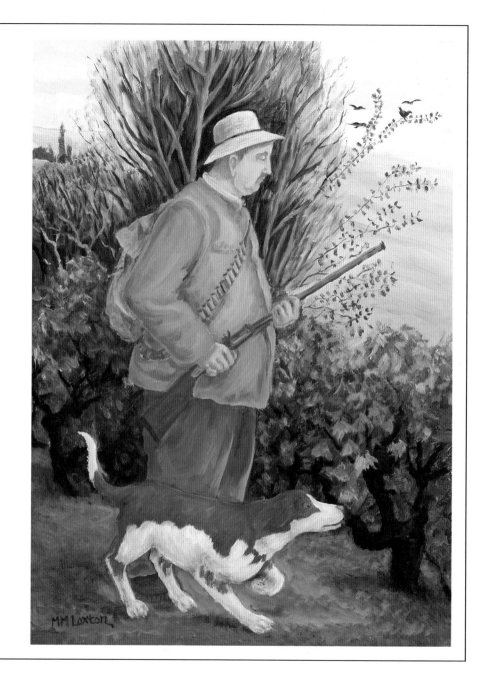

*Huntsman
and his Dog,
Bonnieux*

dogs and chickens, and gave the general impression that he was happy with the way in which his corner of Provence had been depicted. And then he came to a painting that made him put down his drink – always a sign that his attention has been fully engaged.

He placed both hands on the table, and bent over to look more closely, his brow furrowed, his face intent. I thought for a few moments he had found something that displeased him, possibly a row of vines planted slightly awry, or a café scene in which the customers weren't drinking. But when he spoke I knew that all was well.

'*Eh, alors,*' he said, and there was a note of satisfaction in his voice, as though he had made a significant discovery. '*Eh, alors,*' he repeated, and tapped the paper with a heavy finger. It remained planted firmly on one particular figure, a thickset man with a stick and a flat cap who was supervising other figures as they bent over clumps of lavender. He nodded again. '*C'est Roussel, vous voyez? Et son fils. C'est bien fait.*'

Well, I thought, artistic approval from a local expert is praise indeed. And, if he can pick out his neighbour from the dozens of characters that make these paintings such a delight, there can be no doubt about the artist's accuracy.

Bien fait, Madame Loxton, *bien fait*.

Peter Mayle

Village Boules Match, Lubéron

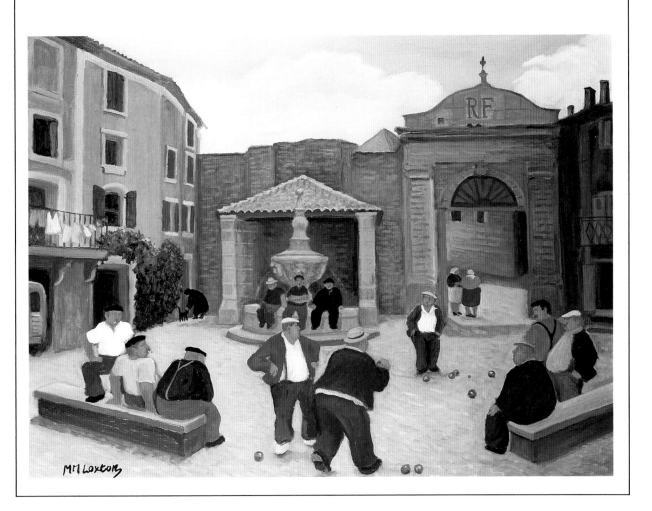

MM Loxton

One of the prettiest coastal villages in Provence, Cassis is the perfect place for an outdoor lunch in springtime. The *bouillabaisse* comes from the sea in front of you, the wine comes from the vineyards behind you, and the waiter probably comes from Marseille, which means that you will be treated to a highly exaggerated but very entertaining description of the delights of his particular recommendations.

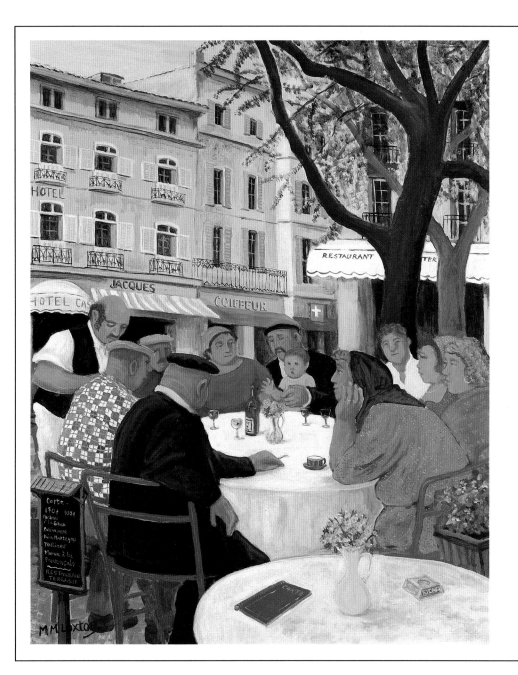

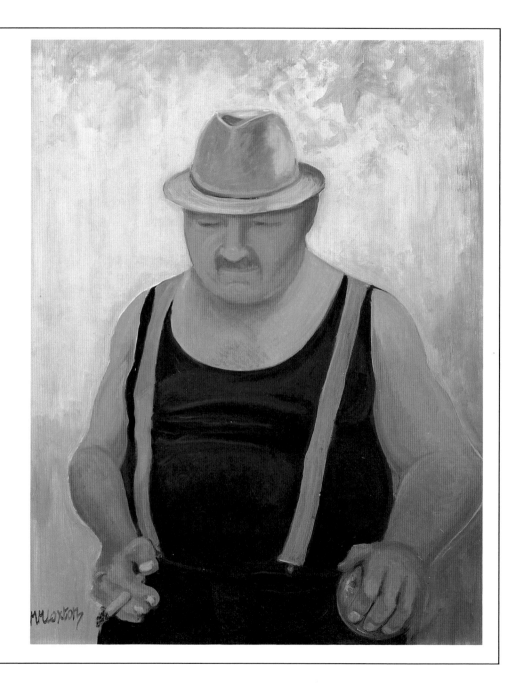

*The Boules
Champion*

Somewhere, in every Provençal village, there is a dusty, often uneven patch of ground where men (never, to my knowledge, women) play a seemingly endless *boules* match. It's a game you can hear from a distance on a quiet summer afternoon; the thud and chock of the steel balls, grunts of triumph or despair, muttered imprecations. And always there is the expert, the ace who can drop his *boule* on a ten-centime piece or the toe of a trespassing spectator with an effortless flip of the wrist. This is the man you do not play against for money.

There are approximately 170,000 residents of Aix, and a large proportion of them (and their dogs) seem to spend the greater part of the day in cafés. This is, of course, much more agreeable than work, and more interesting too, since there is always some minor drama taking place on the streets. Occasionally, the drama extends inside, as it did not long ago in Les Deux Garçons, where police found 15 sticks of dynamite planted in the *toilettes*.

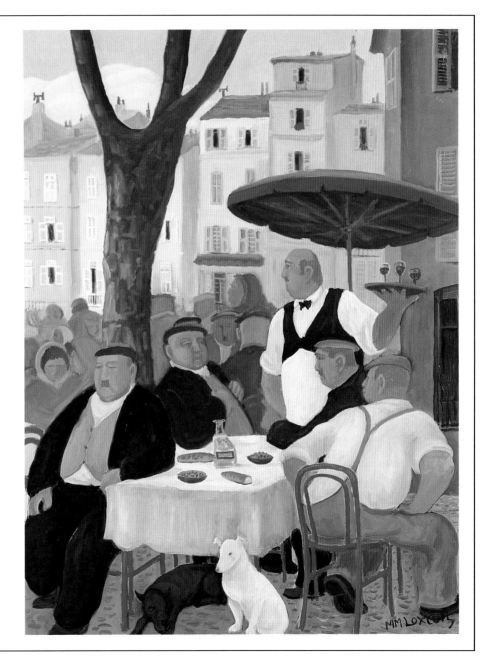

Pavement Café,
Aix-en-Provence

I've often wondered how the Provençal man ever earned the reputation of being a male chauvinist. From what I've seen it is usually Madame who runs the house, does the accounts, invests the money and generally takes charge of daily life (leaving her husband to supervise world affairs with his friends in the café). In between these duties, the ladies of Provence like to stop from time to time, as they're doing here, to congratulate each other on their wise choice of husbands. Or, at least, that's what I like to think.

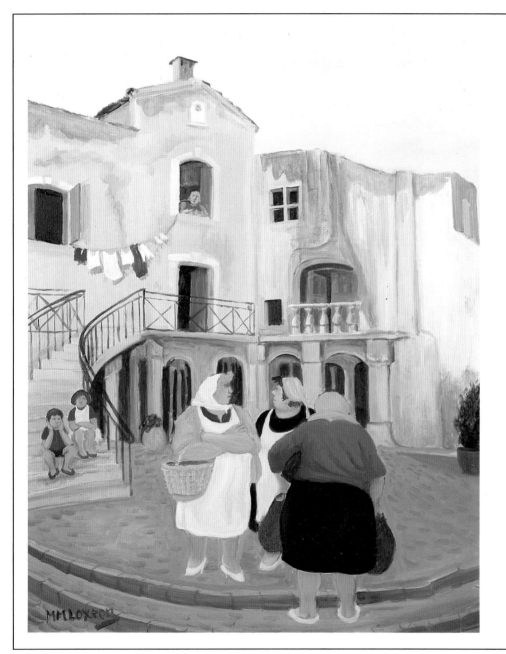

*Three Ladies
of the Lubéron*

Arles Market

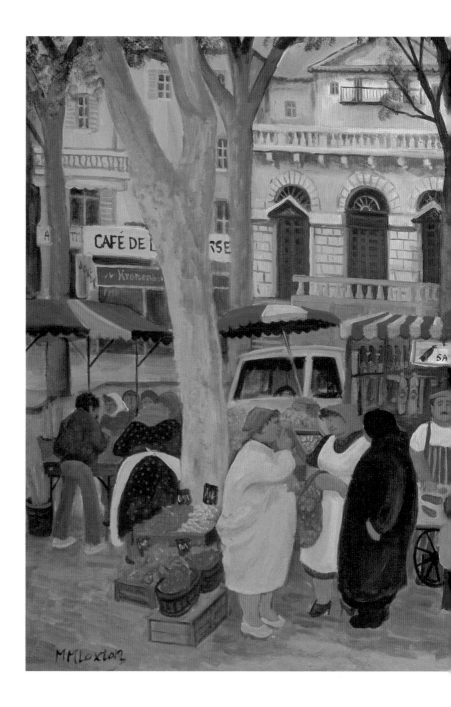

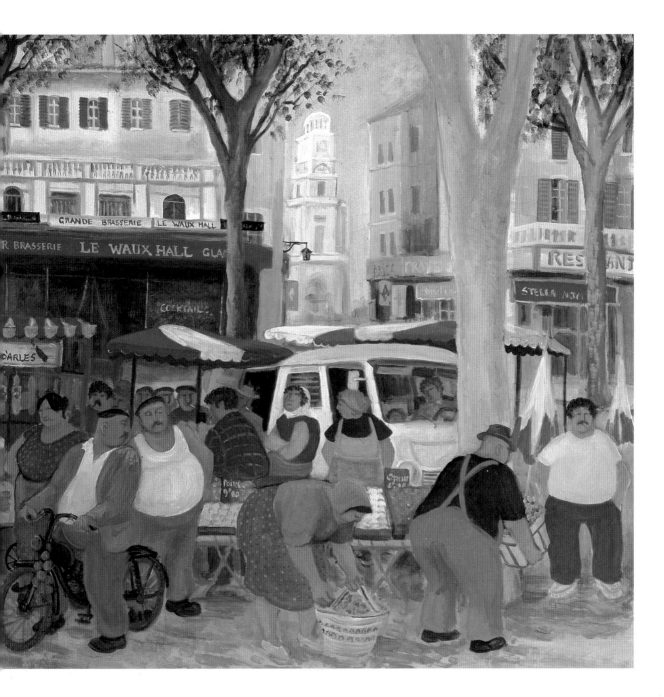

During his time in Arles, between 1888 and 1889, Van Gogh's output would have exhausted half a dozen normal artists. Stimulated perhaps by the women – reputedly the most beautiful in France – and nourished by the local speciality (donkey-meat sausage), he painted 300 canvases in less than 18 months before cutting off his ear and committing himself to hospital. Today, other artists display their work in the gallery named after him. But, of those 300 canvases, not one remains in Arles.

Arles Café

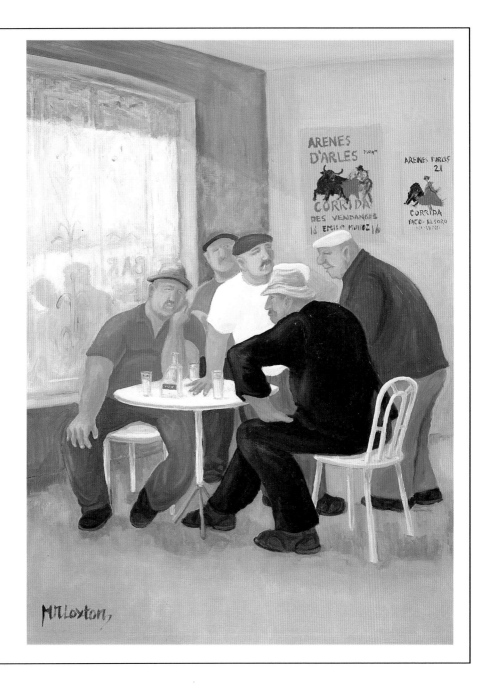

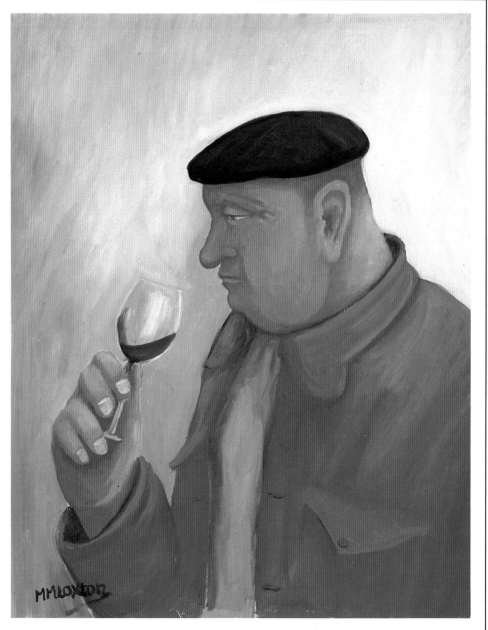

The Cellar-man

Ah, the communion of nose and glass, the swirling and sniffing and measured, reflective sipping – these are just part of the pleasure of buying wine in Provence. But, in fact, buying wine in Provence is never the swift and uncomplicated errand you might imagine. There are so many amiable gentlemen happy to throw open the doors of the *caves* and line up the bottles in front of you that it takes more self-control than I have ever possessed to make a quick decision and a speedy exit. Going out to buy wine is going out for the day, and very nice it is too.

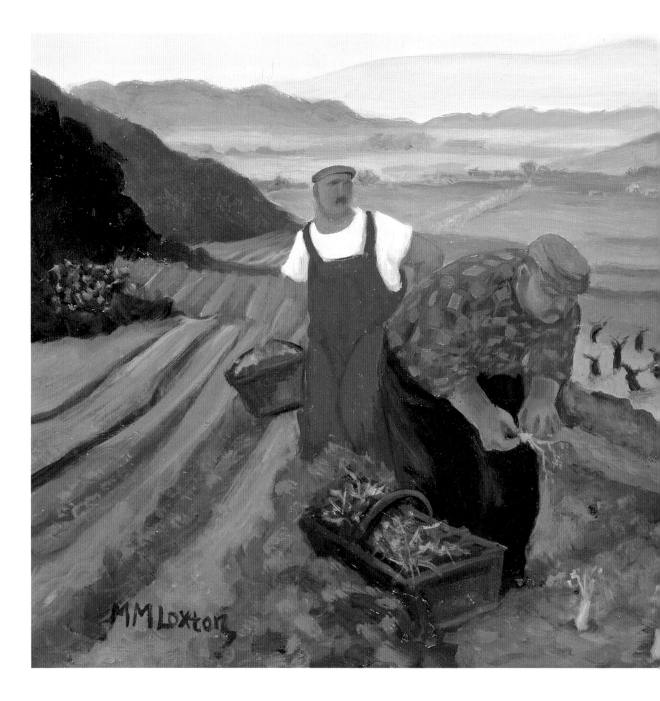

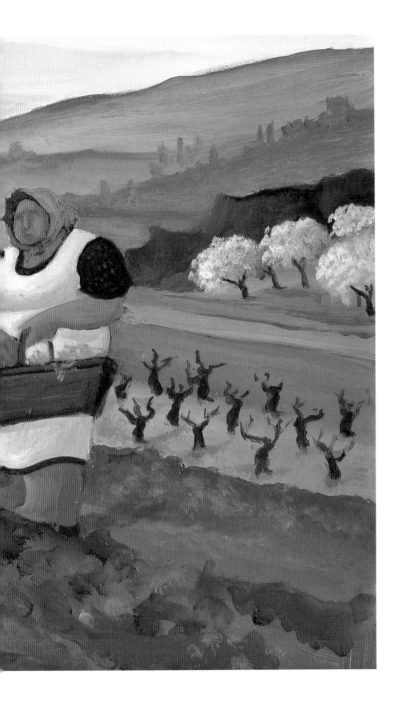

Planting Out

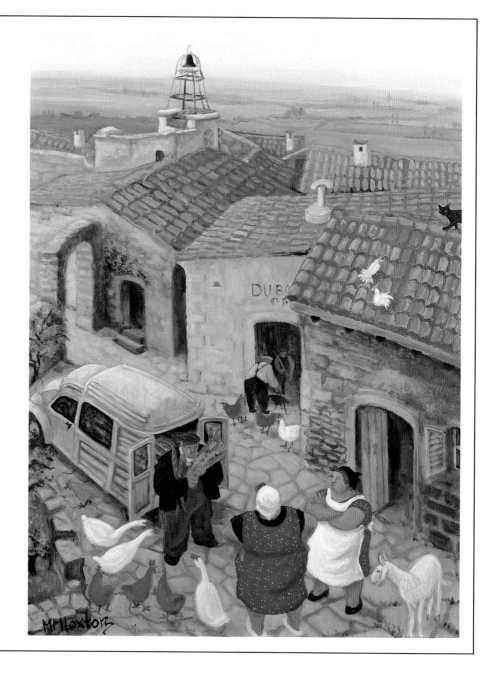

The Bread Van

I know it's convenient, the bread van. And, if you have a husband, a brother-in-law, two cousins from the Ardèche, chickens, geese, goats and a vineyard to look after, there isn't enough time in the day to go to the bakery. But what a sacrifice. Where else but a bakery do you inhale that warm and fertile smell, see those fat rows of croissants, those tarts polished with glaze, those breads speckled with olives or crusted with cheese? And some of them – the most convivial bakers – also sell champagne. I'd be inclined to ask the van driver for a lift back to the bakery.

Any visitor with sufficient stamina can go to a different market on each day of the week – Apt, Aubagne, Cavaillon, Carpentras, Forcalquier, Isle-sur-la-Sorgue – the list is as long as the menu at a four-star restaurant. And in addition to the town markets are the tiny village markets, often no more than half a dozen stalls selling flowers and fruit and vegetables and local honey. The best time to buy is either very early in the morning (for the greatest choice), or just before everyone packs up at lunchtime (for the bargains).

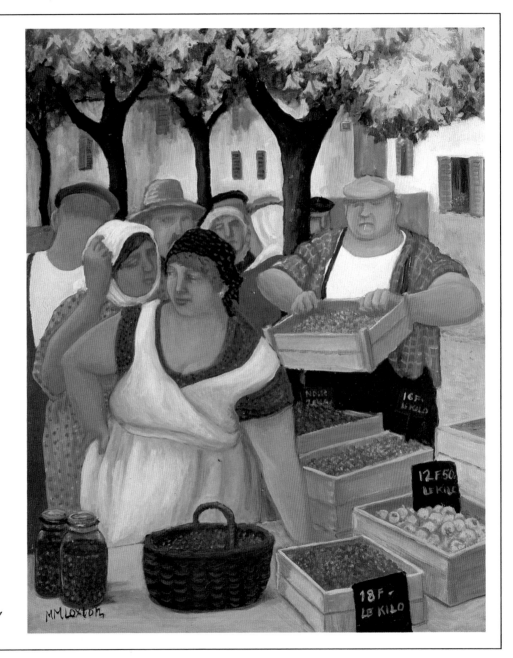

Fruit Market, Bonnieux

Every town in Provence, and every village, has its own modest version of the Elysée Palace, where major political and economic decisions are made, cabinet ministers are shuffled or vilified, and agricultural subsidies defended down to the final drop in the glass. Only a serious game of *boules* or lunch can interfere with these plans for the social rearrangement of France. But they will be resumed, later in the day, when *pastis* takes over from wine, to make the argumentative fingers wag more ferociously than ever.

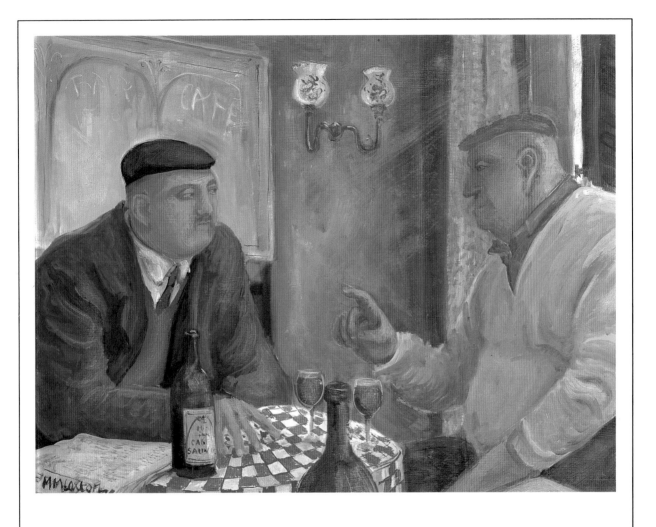

The Union Men

The dog is looking quizzical, the two women seem pessimistic about how many mouths will be fed by the two rather puny birds held up by the hunter. In rural France, birds however small are literally 'fair game' for the pot. The Anglo-Saxon attitude is usually more squeamish. Perhaps the English prefer something that looks big enough to put up a decent fight; or perhaps it is simply a cultural difference to do with French logic and English sentiment.

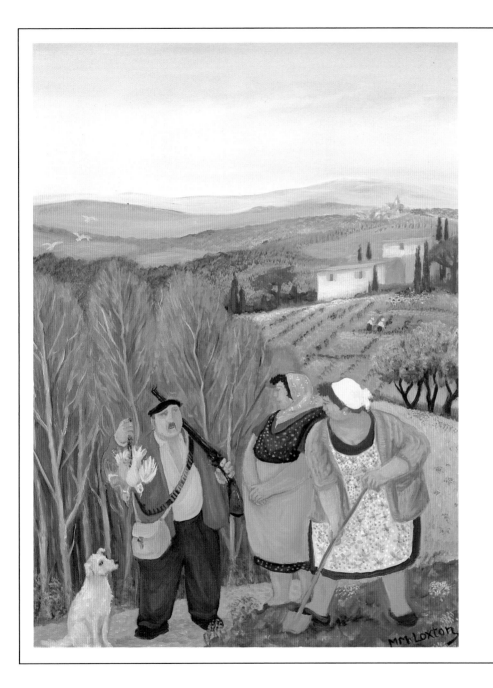

After the Shoot

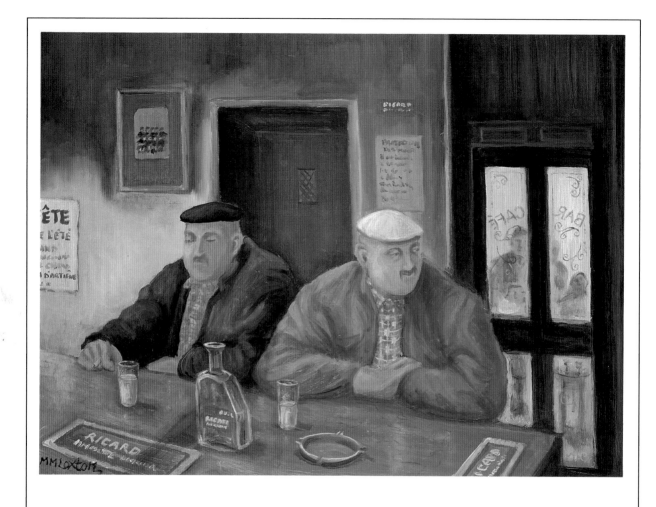

A Quiet Moment

A *pastis* or two, a desultory conversation, the prospect of a good meal – this is what café life is all about. These two have worked hard for their quiet moment.

France is a country where you can still find that most civilized amenity, the restaurant table for one. With nothing as frivolous as conversation to distract him, the gourmet can give his full attention to the plate and the glass, lifting his head occasionally between mouthfuls to nod for a second bottle or another basket of bread, acknowledging nobody except the waiter, at peace with his stomach. At last, with maybe a *digestif* and a muffled belch to help him on his way, he pushes back his chair and leaves, stopping only to ask what's for lunch tomorrow.

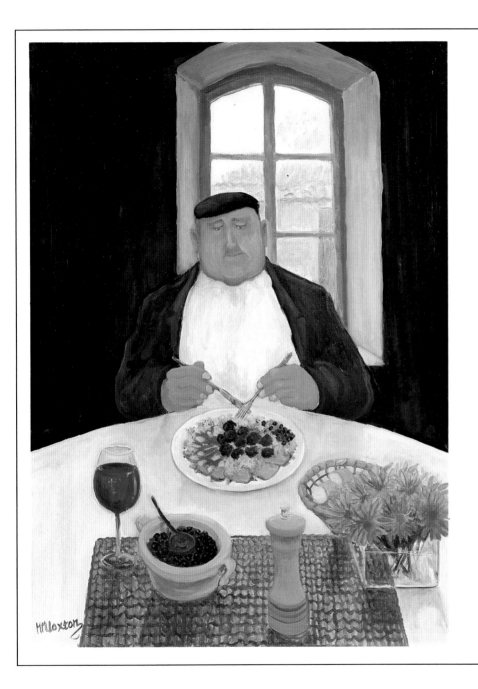

L'Homme à Table

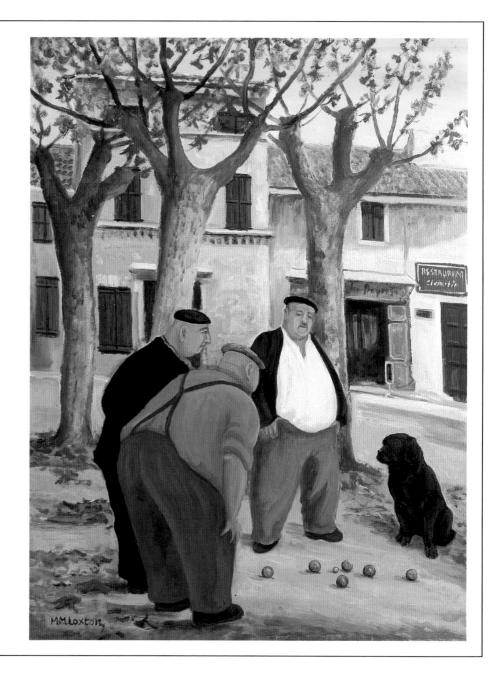

The Boules
Enthusiasts

Boules is a serious game. It arouses tempers, and rivalries, and memories of past triumphs and near-triumphs. It is rather like fishing. It is the one that got away which lingers in the mind. These three corpulent gentlemen are scheming. So is the dog.

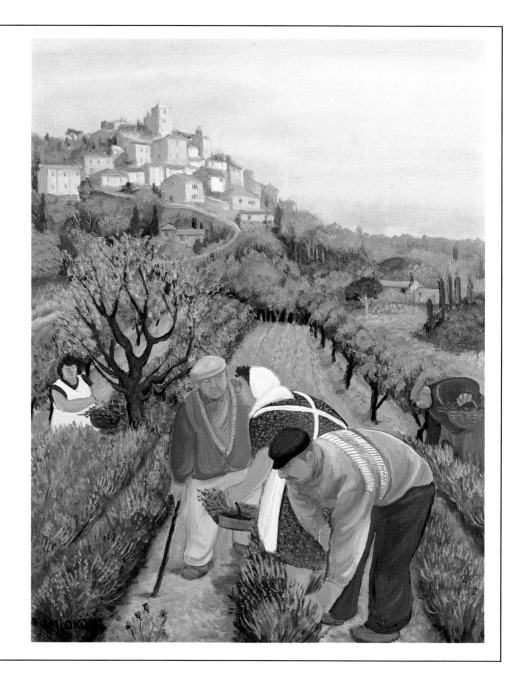

Lavender
Harvest,
Lacoste

Lavender is one of the great Provençal industries. People depend on it for their livelihood, just as other people in Mediterranean countries rely on the olive. It will be harvested for soap, for various unguents and oils, for stuffing cushions, and just to make up into bunches and be sold in local markets.

Aix is the great place for fountains, but every town or village has its fountain, usually modest, sometimes startlingly grandiose, as if Louis XIV had passed that way and decreed a memento of Versailles. The fountain in Venasque is comparatively modest, but provides a welcome resting point at the town centre where one can relax, gossip or let the world go by – and a refuge from the searing Provençal sun.

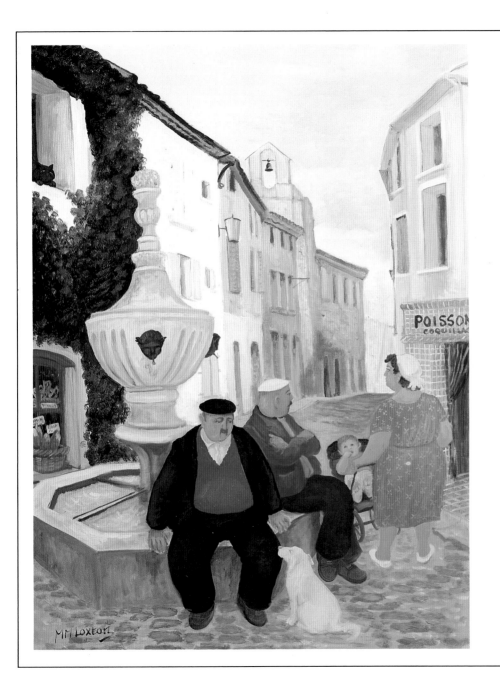

*Fountain
in Venasque*

The preparation of any meal – but perhaps above all supper – is a serious matter. This might be the beginnings of an omelette, or a *pipérade*, or some other mixture of eggs and vegetables. With some warm crusty bread, this is at least a start, though no self-respecting Frenchwoman would consider this as more than an adequate *amuse-bouche*. Time alone – as marked on the surprisingly elegant clock – will reveal what comes after.

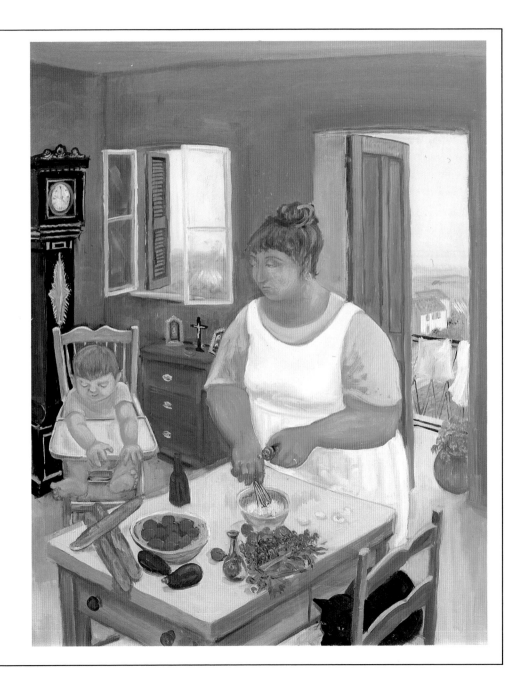

*Preparing
Supper*

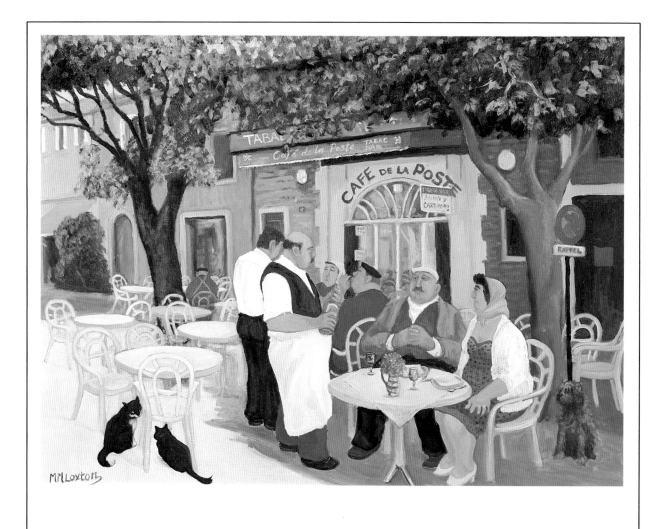

Café de la Poste, Goult

A quintessential Provençal sight. A couple sit at a wrought-iron table, while the *patron* prepares to pour the essential *apéritif*. There will be serious discussion of the various dishes of the day. A soup? A little fish? Some pork or a *carré d'agneau*, or, if the season is right, a *salmis* of pheasant or some other luckless bird? The opportunities for the *patron* in preparing the menu are endless and the combinations for a daily choice are worked out with care and discrimination and much questioning banter.

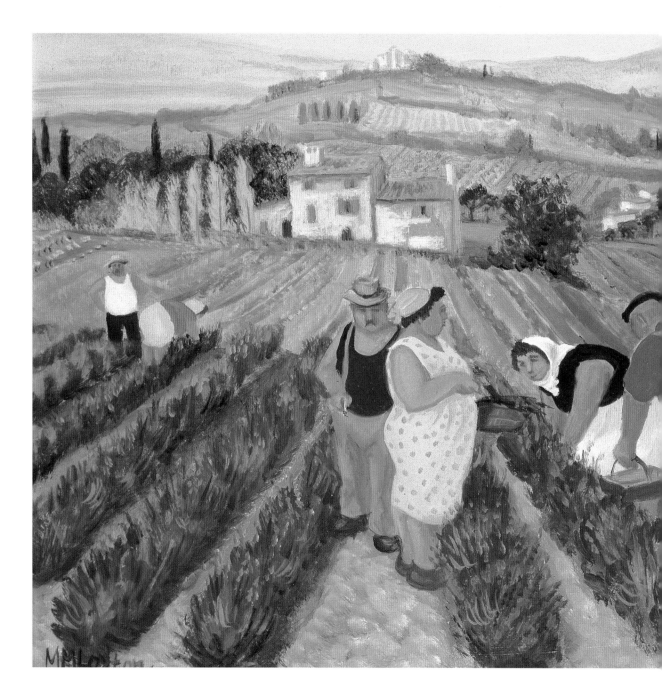

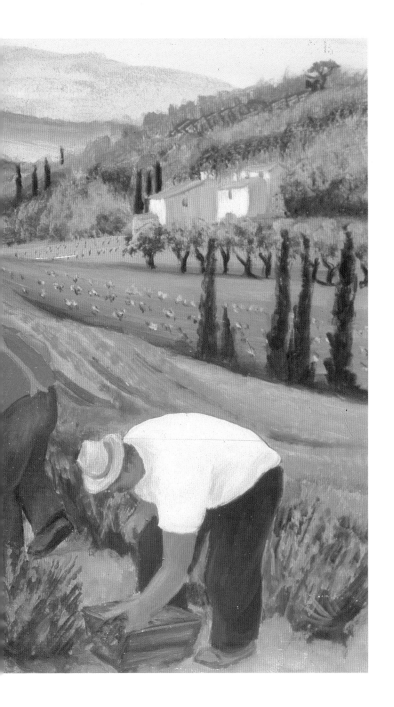

Lavender, near Roussillon

Pavement Café,
Apt

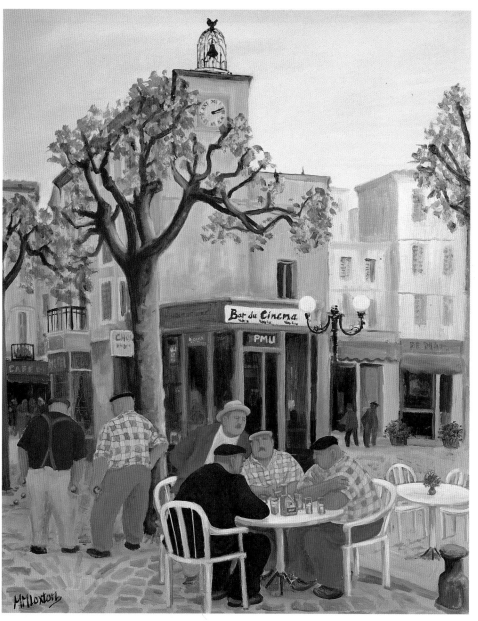

The afternoon is in full swing, if such a phrase can be applied to such a scene of repose. A few more drinks, a few stories, a gentle game of *boules* under the shade of the plane trees. Why hurry? Nothing is going to change. The world will be exactly the same in a couple of hours' time.

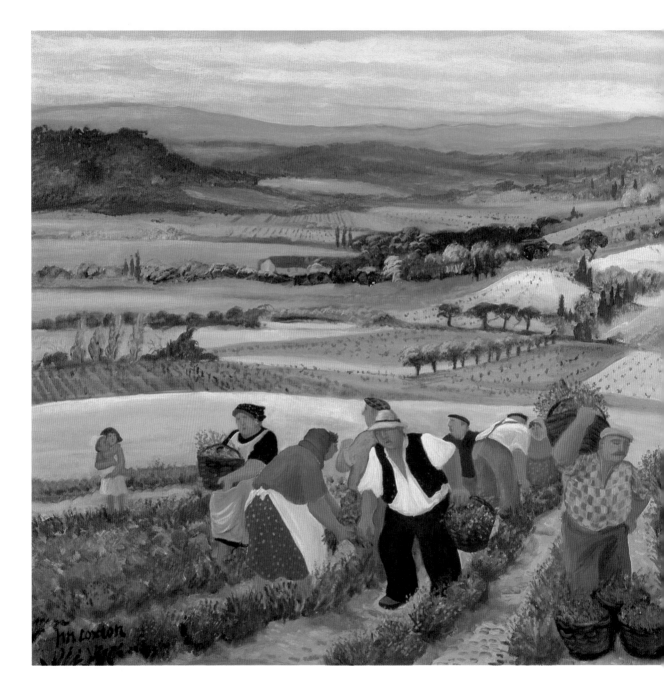

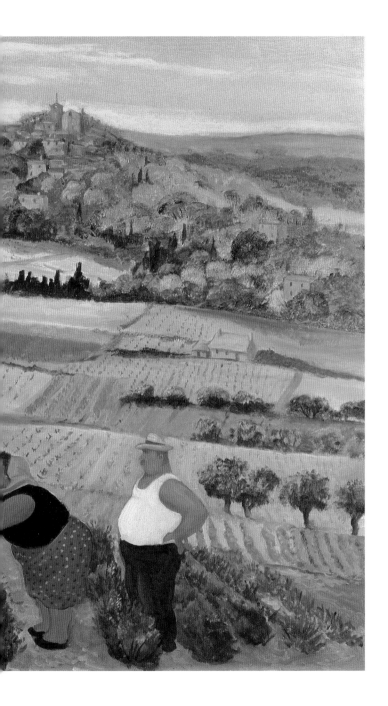

Lavender Pickers,
Aurel, Vaucluse

Café de France,
Isle-sur-la-Sorgue

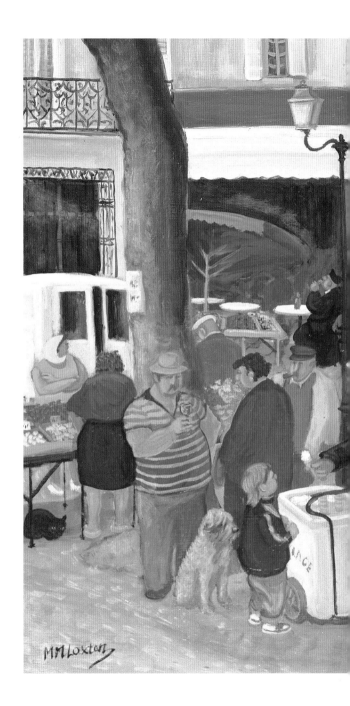

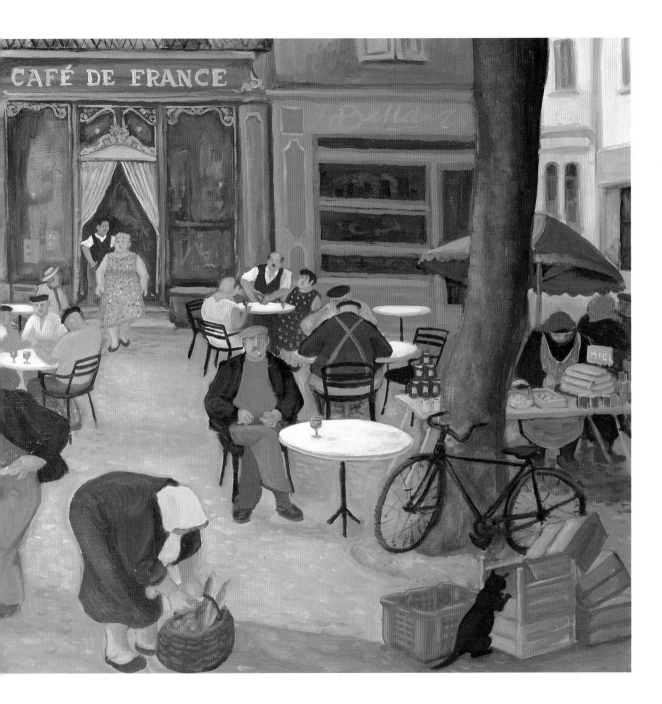

Olive Grove and Sunflowers

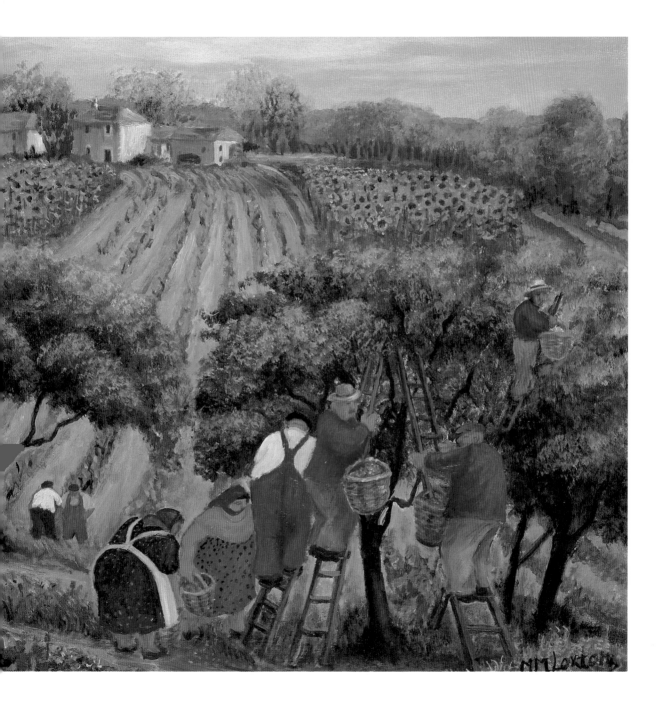

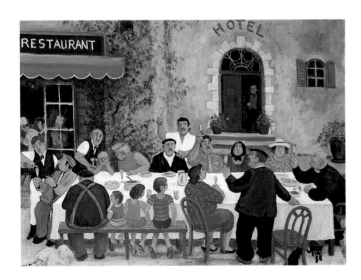